FRAMES

Nicholas Penny

POCKET GUIDES

NATIONAL GALLERY PUBLICATIONS LONDON

DISTRIBUTED BY YALE UNIVERSITY PRESS

This publication is supported by
The Robert Gavron Charitable Trust

For Joan Nance

THE POCKET GUIDES SERIES

OTHER TITLES

Allegory, Erika Langmuir
Conservation of Paintings, David Bomford
Landscapes, Erika Langmuir

FORTHCOMING TITLES

Colour, David Bomford and Ashok Roy
Faces, Alexander Sturgis

Front cover: Imitator of Lippi, *The Virgin and Child with an Angel*, with
Florentine frame, 24.
Title page: Italian frame, about 1560, 26.

© National Gallery Publications Limited 1997

Vuillard, *Madame André Wormser and her Children*, 1926–7,
© ADAGP, Paris and DACS, London 1997

First published in Great Britain in 1997 by
National Gallery Publications Limited
5/6 Pall Mall East, London SW1Y 5BA

ISBN 1 85709 165 5

525237

British Library Cataloguing-in-Publication Data.
A catalogue record is available from the British Library.
Library of Congress Catalog Card Number: 97-67666

Edited by Felicity Luard and Nicola Coldstream
Designed by Gillian Greenwood
Line drawings by Roderick Heyes
Printed and bound in Great Britain by Ashdown Press Limited, London

CONTENTS

FOREWORD

The National Gallery contains one of the finest collections of European paintings in the world. Open every day free of charge, it is visited each year by millions of people.

We hang the collection by date, to allow those visitors an experience which is virtually unique: they can walk through the story of Western painting as it developed across the whole of Europe from the beginning of the Renaissance to the end of the nineteenth century – from Giotto to Cézanne – and their walk will be mostly among masterpieces.

But if that is a story only the National Gallery can tell, it is by no means the only story. The purpose of this new series of *Pocket Guides* is to explore some of the others – to re-hang the Collection, so to speak, and to allow the reader to take it home in a number of different shapes, and to follow different narratives and themes.

Hanging on the wall, for example, as well as the pictures, is a great collection of frames, with their own history – hardly less complex and no less fascinating. There is a comparable history of how artists over the centuries have tried to paint abstract ideas, and how they have struggled, in landscapes, to turn a view into a picture. And once painted, what happens to the pictures themselves through time as they fade or get cut into pieces? And how does a public gallery look after them?

These are the kind of subjects and questions the *Pocket Guides* address. Their publication, illustrated in full colour, has been made possible by a generous grant from The Robert Gavron Charitable Trust, to whom we are most grateful. The pleasures of pictures are inexhaustible, and our hope is that these little books point their readers towards new ones, prompt them to come to the Gallery again and again and accompany them on further voyages of discovery.

Neil MacGregor
DIRECTOR

INTRODUCTION

Picture frames

Their effect on paintings

Frames as shrines

Frames as furniture

The language of frame-making

It has become easier than ever before to see paintings without frames. Many old masters, especially in Continental museums, are exhibited in this way. Some modern artists prefer to do without them. Moreover, most people are introduced to pictures either as colour slides glowing out of the dark of a lecture hall or as coloured plates bordered with white in a book. Perhaps it is precisely the absence of frames in reproduction that has promoted more awareness of their presence around the real thing.

Anyone who has framed a painting will be aware of the difference it can make, will know how a frame can draw the eye into the depths of a picture, increase the discipline of its composition, give (if it is black) an emphasis to the whites or increase (if it is gold) the sonority of the blues. Sometimes the effect is such that we speak of a 'perfect marriage'. This expression, however, seldom indicates an equal partnership. The frame is subordinate. It is made, or found, and sometimes cut down for the picture, and many a frame, even after centuries of loyal but discreet service, has been carelessly discarded.

Picture frames belong to the history of furniture as well as to the history of painting. One reason why they were often changed is because they were designed to match a room as well as the picture. There are many splendid frames that, when we step back, do not live happily with their paintings and are now bereft of the furniture to which they did relate. In other cases a 'perfect marriage' is effected. But the happy couple, if we step back further, may turn out to get on very badly with their neighbours. Awareness of picture frames promotes irritation at the disjointed character of most modern museum displays, which many frame makers in the past were anxious to avoid. It also helps us to understand how profoundly our attitudes to paintings are conditioned by the circumstances of their display. Frames are thus not merely a marginal subject for the history of art.

The Funeral of Saint Francis [1] by the Sienese fifteenth-century artist Sassetta depicts a gothic frame around an altarpiece. Within its three principal arched divisions Saints Peter and Paul stand on either side of the Virgin and Child; rising above are three smaller images. The shape of the frame not only reinforces the

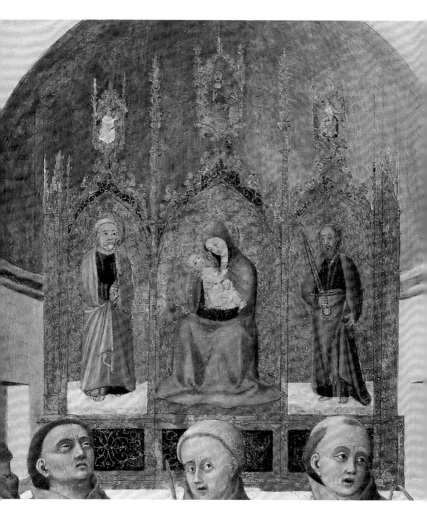

priorities of the worshipper, giving the Queen of Heaven a place of special honour, but its fragility and elaboration seem marvellous, a work of manifest skill, which pays tribute to the sacred, as does the gold, a material of conspicuous value. It is completely different to the frame as we know it today, which is designed to help us to handle and hang a painting safely – for such a gothic altarpiece would have been difficult to move and was not hung at all. We think of a frame as providing a border that isolates and contains a rectangular canvas, but in such an altarpiece the image cannot be separated from its frame and, as we shall see, it was physically attached to it.

1. Sassetta, *The Funeral of Saint Francis and the Verification of the Stigmata*, Siena, 1437–44, detail.

7

2 (opposite). Edouard Vuillard, *Madame André Wormser and her Children*, Paris, 1926–7, detail.

The familiar modern frame is not, however, chosen only for practical reasons, nor only because it suits the painting. A frame is chosen to make a good impression when the painting is not being looked at, but simply 'taken in' with the silk of a lampshade, the rosewood of a piano and the porcelain of a teacup [2]. A frame can elevate a painting to sacred status but it can also unite it with the comforting textures of the affluent home. During the course of this book we will frequently touch on these extremes: the frame as shrine and the frame as furniture.

DESCRIBING FRAMES

The language for describing picture frames is complex. It involves some carpenter's terms ('dowels', a type of peg, or 'lap-joint', a type of right-angled join), but also some architectural vocabulary both for basic forms (such as 'gables') and ornament (such as 'bead and reel' – for which see p. 58). Some ornament is completely abstract in character, as for example the pattern known as 'arabesque' derived from Islamic sources – textiles and metalwork especially. In the example illustrated here [3] it appears in the frieze of an Italian sixteenth-

3. *Sgraffito* decoration on the early sixteenth-century north Italian frame on Francesco Morone's *Virgin and Child*, probably 1520–9.

century frame scratched through paint to reveal the gilding below (a technique known as *sgraffito*). In other cases ornament can be highly naturalistic, often consisting of fruit or flowers. The wooden cherries [4] from the frieze of another Italian Renaissance frame are actually attached by wire stems. They were glazed with a translucent red pigment over gold but this has now darkened, as has the blue background.

Frame-makers and frame-dealers have their own terminology, some of it self-explanatory if unfamiliar ('pierced and swept'), but some of it puzzling – for

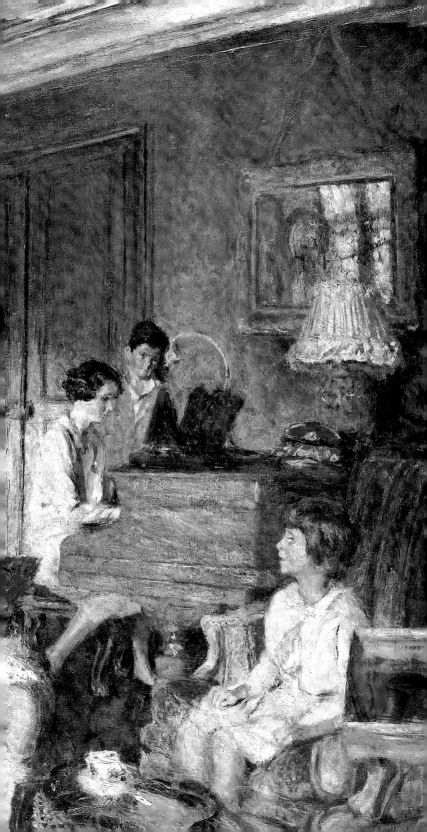

4. Wooden cherries attached by wire to the sixteenth-century north Italian frame on Giovanni Bellini's *Madonna of the Meadow*, about 1500.

example, the 'Carlo pattern', to be explained on page 45. In this book the language has been deliberately kept simple and, where appropriate, terms have been explained. Full glossaries are supplied by some of the books in the appendix on further reading.

This is not a chronological account of the European picture frame. Nor is it even a guide to all the major types of frame. It will be of little practical use (although I hope of some interest) to those who make picture frames. It is an introduction to some of the main styles and to the basic methods of manufacture and decoration of frames, and also to some of the most interesting questions that frames provoke.

We first look at original frames, most of which have remained around paintings of the early Renaissance or of the nineteenth century. The following sections trace some of the ways frames developed in different parts of Europe in response to changing methods of display. The last chapter looks closely at the techniques and detail and finish of frames that have earlier been discussed more generally. The book is illustrated entirely by works in the National Gallery, where a framing department is active repairing, adapting and acquiring old frames, and also imitating some of them (more or less exactly depending on the case). The visitor to the Gallery will not always find it easy to identify old frames, let alone original ones, but notes on the more exceptional frames are now included on the picture labels.

ATTACHED FRAMES

Frames integral to the
painted support

Frames secured to the
painted support

Continuity with the painting

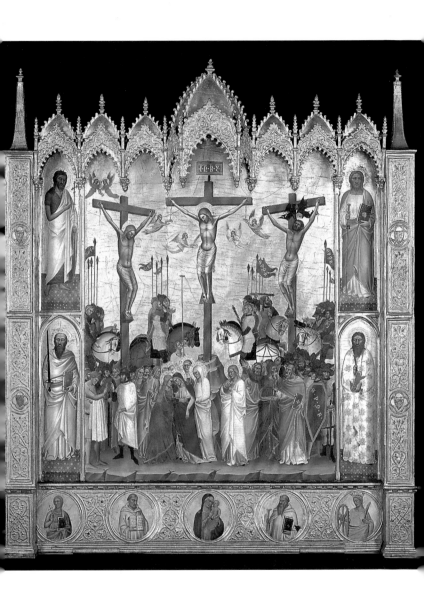

5. Attributed to Jacopo di Cione, *The Crucifixion*, Florence, late 1360s, 154 x 138.5 cm.

Very few paintings in the National Gallery, or in any other major public collection of European art, are still surrounded by the frames that were originally designed or chosen for them. It may seem surprising that a good many of those that do remain are to be found around the earliest paintings, the most remarkable case in the National Gallery being a gothic frame of a *Crucifixion* made in Florence probably in the late 1360s [5], which is likely to have served

12

6. Detail
of frame in 5.

as an altarpiece in a chapel – perhaps a gothic chapel, with a vault painted blue with gold stars like those that still shine within the darkened interiors of the canopies of this frame if we look up at the painting from a kneeling posture [6]. Such projecting canopies are unusual in a painted altarpiece but were commonly found in sculptural ones where they provided the sacred image with shelter (hence *guardapolvo*, meaning dustguard, their name in Spanish).

Within fifty years of being painted, this altarpiece would have been regarded as old-fashioned. No one would have wished to incorporate it into a new chapel in a more modern taste or to remove it to a secular picture gallery before the late eighteenth century. By then its gothic frame would have appealed to the antiquaries who were fascinated by the Middle Ages and the early phases of European painting. It doubtless helped that the altarpiece was unusually small (for many gothic altarpieces were too large for the galleries of private collectors and were therefore dismembered). But crucial for this frame's survival was the fact that it was not a separate object into which the painting was inserted but was nailed and glued to the poplar panel on which the painting was made and covered with the same layers of white plaster (gesso), orange clay (bole) and gold leaf that are found in the painting itself.

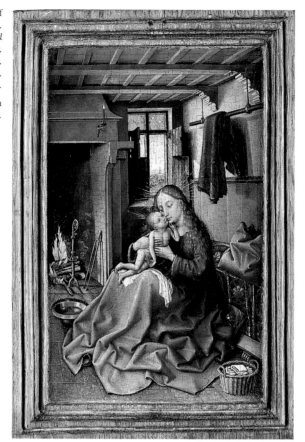

7. Workshop of Robert Campin, *The Virgin and Child in an Interior*, Tournai, about 1435, 22.5 x 15.4 cm.

8 (below). Section of the frame in 7.

ATTACHED AND INTEGRAL FRAMES

Some frames around early European panel paintings were not only attached in this way but were constructed out of the same piece of wood as the support of the painting itself. A good example of this is the little *Virgin and Child* probably produced in the 1430s in the workshop of Robert Campin [7]. As was usual in Netherlandish paintings the support is oak. The vertical grain of this wood is clearly visible in the upper and lower mouldings, which have been largely stripped of their original gilded surface.

It is tricky to chisel mouldings such as these against the grain and it was more laborious to prepare a smooth surface for painting if the panel was not entirely flat. Jan van Eyck's *Man in a Turban* of 1433 has a frame that is half-integral [9] – an unusual arrangement found on some other paintings by him. Whereas the sides of the frame are part of the same

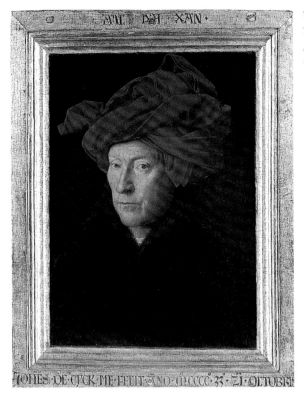

9. Jan van Eyck,
A Man in a
Turban, Bruges?,
dated 1433,
33.3 x 25.8 cm.

10. Detail
of frame in 9.

11. Section of the
frame in 9 and 10.

10 11

piece of wood as the painted panel, the upper and lower mouldings are attached with dowels which have slightly disturbed the gilding [10]. The chief reason for this method of construction seems to have been the artist's desire for mouldings that were finer and sharper than the more usual ones [8 and 11]. Such mouldings could be cut with new planes that would have been difficult to operate against the grain, and impossible at the corners.

12. Jan van Eyck, *Portrait of a Young Man*, dated 1432, in its frame of tortoiseshell with a gilded slip, probably English, about 1860, 46.9 x 33 cm. The slip imitates the mouldings of 9.

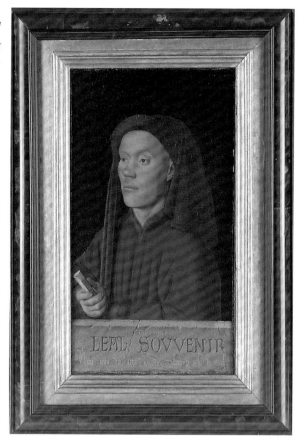

CONTINUITY BETWEEN FRAME AND PAINTING

The usual situation today, and indeed for several centuries, has been for an artist to make a painting and then to decide upon a frame, but the frames we have been considering were attached before the artist picked up his brush: they were inseparable in an artistic as well as a physical sense. Van Eyck inscribed his name on the frame, adding a date and a motto. It was common for frames to carry texts; in the case of devotional pictures, words of praise and prayer. Van Eyck's inscription, painted to imitate chiselled letters, would easily wear away if the frame were handled too much, and originally the whole panel may have been protected by a case or cover. Displayed in a picture gallery the moulded borders appear insubstantial; when the painting was first hung in the National Gallery the frame was treated merely as an inner frame or slip. A tortoiseshell moulding was placed around it – a precious material

doubtless regarded as suitable for a jewel-like painting, and of a tawny colour that matches the red fabric and the lustrous brown fur in the picture itself. This arrangement was then imitated for similar pictures acquired subsequently [12].

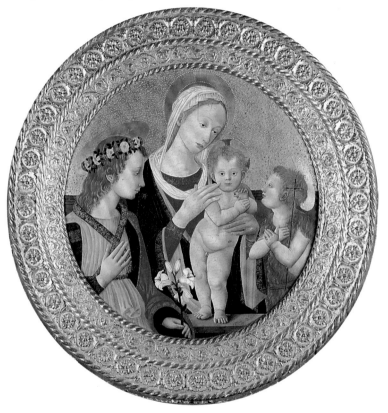

The modern picture gallery originated in the sixteenth century and we know relatively little about how paintings were displayed in secular settings before that date – smaller portraits such as these were probably not normally hung on a wall but stored in chests and brought out on special occasions. Religious pictures were often hung in bedchambers and often in fairly elaborate frames. In Tuscany in the fifteenth century such pictures were sometimes round and known as *tondi*. Although most of them seem to have been given separate frames, one example in the National Gallery retains borders of low-relief gilded decoration on the same panel as the painting [13]. In the case of Van Eyck's portrait we noted the paint on the frame; here, relief decoration, designed

13. Florentine School, *The Virgin and Child with Saint John the Baptist and an Angel*, about 1460, diameter 104 cm.

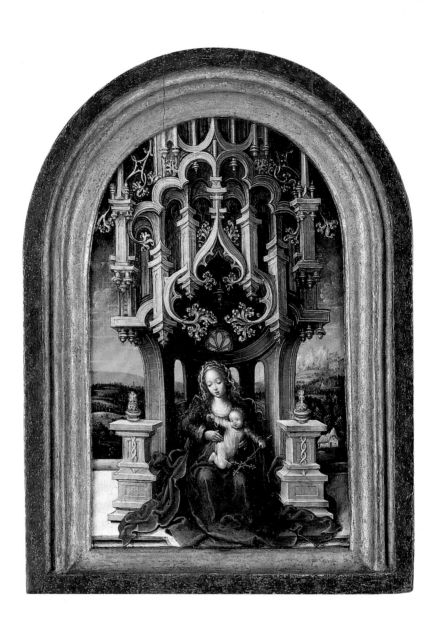

14. Netherlandish
School,
*The Virgin and
Child Enthroned*,
about 1520,
28.9 x 21.5 cm.

to catch the light from candles below, adorns the gilded portions of the picture itself as well as the frame.

The outside edge of this frame is a rim of ungilded wood which does not provide the strong defining closure that one expects. Almost certainly what we see here is only an inner frame and the tondo was inserted in some bolder framing element, perhaps part of the architecture or the panelling of a room.

The increasing popularity of canvas rather than panel as a support must have given an incentive to the use of detachable frames during the sixteenth century in Italy; and gilding was an art that most painters had ceased to practise. But north of the Alps frames continued to be attached to panels. A curious example is a Netherlandish painting of the Virgin and Child of about 1520 [14]. When recently cleaned, not only was the original gilding discovered on the mouldings but on the simple slope along the lower edge – common to many north European frames and imitating the sills of gothic windows – a portion of the Virgin's robe was revealed, painted as if it had spilled out of the picture [15]. The simplicity of this frame reflects the fact that the picture was portable; its frame was designed like those around family photographs today, so that it might be easily handled and packed away. Had it been larger and an altarpiece it might have had a gothic canopy as elaborate and fragile as that depicted within the painting itself.

15. Detail of 14.

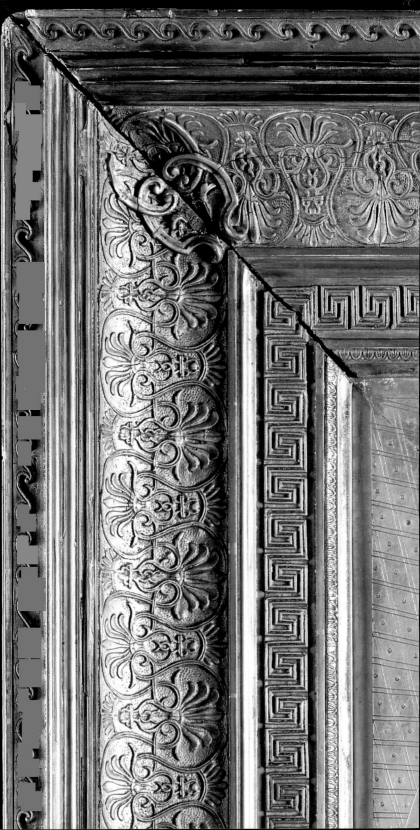

DETACHABLE
FRAMES

Original frames

Tabernacle and cassetta frames

Frames for the picture collector

Frames for the picture gallery

ORIGINAL
FRAMES

Eighteenth-century France

The nineteenth century: dealers' frames

Artists' frames

Second-hand frames

THE
SUITABILITY
OF FRAMES

During the sixteenth century it became increasingly common for the picture frame to be conceived of as part of the furniture of a domestic interior. Yet, although fewer artists designed frames, it is striking how well suited to the painting original frames often are. The one around the portrait of Antoine Pâris, a rich French financier painted by Hyacinthe Rigaud in 1724 [17] is sufficiently rectilinear to echo the vertical and horizontal elements of the composition, but, just as the latter provide a foil for the genial informality of loose wig, unbuttoned shirt and flowing cloak, so the straight lines of the frame are playfully contrasted with the lively movement of the ornamental scrolls and acanthus tendrils. French frames of this style had originated in the mouldings used for the panelling of rooms but with more or less ornament, sometimes in a running pattern, sometimes concentrated at centres and corners, as here where there are sub-centres as well. The centres and sub-centres work well in relation to the axes of the composition and the placing of head and hands.

Depicted within the portrait itself we find the sort of gilded furniture that would have surrounded this frame when it was first hung. Had this painting not been a portrait, but a subject more attractive to collectors, its frame might well have been changed to suit successive owners and fashions in interior decoration.

ON PAGE 20
16. Detail of 19.

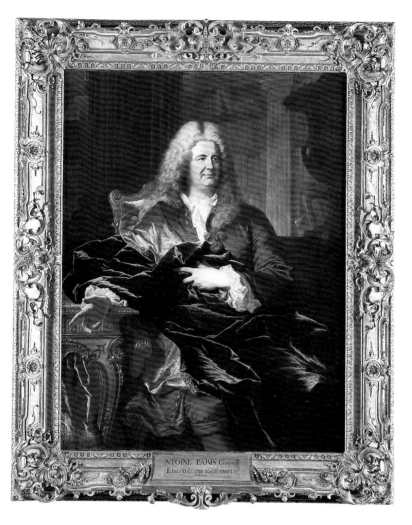

NTOINE PARIS Conseil
Etat né en 1668 mort en

Portraits, however, often retained their original frames, especially when they remained within the family, as this one did, and domestic piety or dynastic pride often ensured that they were well cared for. One alteration was made in this case: a tablet naming the sitter was incorporated somewhat brutally in the lower moulding. This must have been done within the sitter's lifetime because the notice of his death (in 1733) is superimposed on earlier lettering.

There may be a dozen eighteenth-century paintings in the National Gallery within their original frames but few of them are in a condition to compare with this one. There are many more nineteenth-century pictures in

17. Hyacinthe Rigaud, *Antoine Pâris*, Paris, 1724, with original frame, 185.4 x 154.5 cm.

NINETEENTH-
CENTURY
FRAMES

their original – or at least their first – frames, but these were not always supplied by the artist or by the first owner of the painting in consultation with the artist. Moreover, when the artist did choose the frame he or she often did so for the picture's public exhibition, choosing a cheap frame to perform a temporary job. Since pictures in these crowded circumstances had to gain attention, or at least protect themselves from the competition of neighbouring pictures, broad frames of brash character were often favoured. Dealers also chose frames that were available in ready-made patterns. A good example of a typical late nineteenth-century dealer's frame is the one around a landscape by Harpignies [18]. The pattern is based on a carved mid-seventeenth-century French frame but the flowers and leaves are cast in 'compo' – a composition of hard, oil-based plaster, rather like putty, first introduced for this purpose in Paris in the early eighteenth century. Like many nineteenth-century frames, this one was designed for glass, and an additional gilded slip protects the picture surface from contact with this.

18. Henri-Joseph Harpignies, *River and Hills*, 1850s?, with first frame probably about 1880, 56 x 73.2 cm.

Harpignies probably tolerated frames such as this, even if he preferred not to see his paintings in them, but there is no evidence that he selected them. There

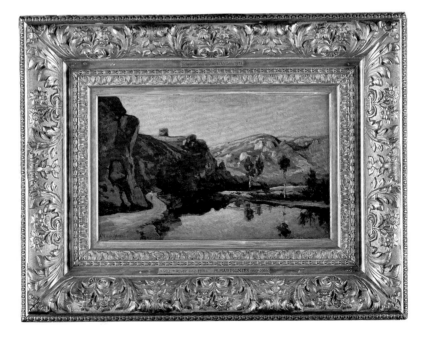

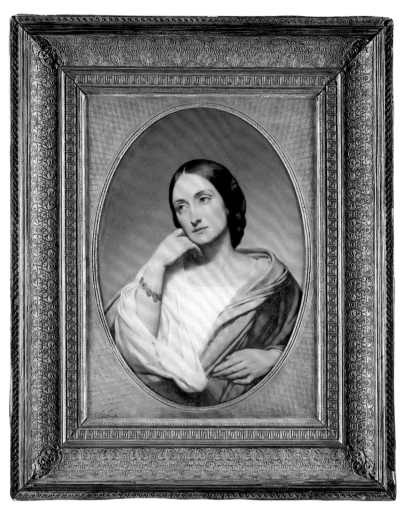

are, however, many nineteenth-century paintings with
frames probably chosen, and even perhaps designed,
by the artist. The frame around Ary Scheffer's portrait
of Mrs Robert Hollond of 1851 [19] has survived partly
because, from a decade or so after it was bequeathed to
the Gallery in 1885, the painting was probably regarded
as of no interest whatsoever. No one would have con-
sidered it worthwhile to fit a more fashionable frame,
especially since the curved edges of the spandrels in
the corners would have been an extra expense and
difficulty. The ornament is cast in composition like that
on the frame on the landscape by Harpignies – but it is
in very shallow relief and consists of minute, repeated

19. Ary Scheffer,
*Mrs Robert
Hollond*,
Paris, 1851,
with original frame,
122.7 x 101.7 cm.

elements that would have been tedious to carve. The Greek key pattern, the interlaced honeysuckle (or anthemion) and the tiny wave pattern (or Vitruvian scroll) provide the right quiet accompaniment to the archaic robes and slightly melancholy, distant mood of the sitter. The tone of the gold is perfectly calculated to enhance the blue of the sky and eyes and the pink of the cloak. As often occurs, the 'compo' has cracked as it has dried and some of it has fallen off. There are also losses at the corners where the joints have opened as the wood has shrunk [16].

IMPRESSIONIST
FRAMES AND
SECOND-HAND
FRAMES

We can learn a lot about picture frames from the way they are represented within paintings. A striking example is Manet's portrait of Eva Gonzalès. She is shown painting a still-life that is already surrounded with a frame [20]. Manet's painting, dated 1870, was shown in the Salon in that year. At that date many of his friends and associates among the Impressionists and their circle were experimenting with simple mould-ings painted white. Here is good evidence that some of them still favoured gilded frames. Perhaps the painting also tells us that some modern artists have painted their canvases (or at least have completed them) in frames; but the image seems closer to allegory than documentary realism. The frame depicted here is in the early neo-classical style of the reign of Louis XVI, with severely architectural mouldings, usually with a flat frieze, and trophies, ribbons and swags employed as a crowning feature. In this example swags are apparently threaded through the frieze. It is likely to be a genuine old frame – thus an early example of the use of the second-hand frame.

In the second half of the nineteenth century, when old frames were adopted for new paintings, it became possible for the first time to speak of a picture's original frame which was, paradoxically, not original to the picture. An attractive example in the Gallery's collection is the fine frame around the small sketch of a bather by Renoir [21]. The painting probably dates from the late 1880s. Its frame was made in the early eighteenth cen-tury. Since the artist saw himself as part of a tradition of French decorative and sensuous pastoral painting, chiefly associated with the eighteenth century, the choice of such a frame by him, or more probably by a dealer, was apt. But the finish on this frame and others

20. Edouard
Manet,
Eva Gonzalès,
Paris, 1870.

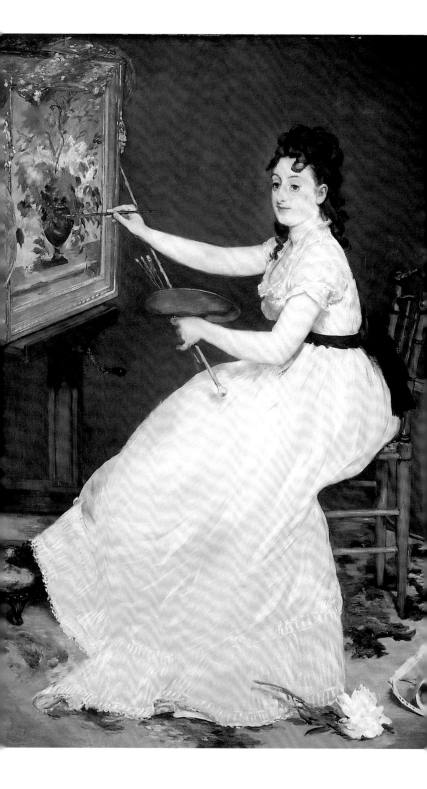

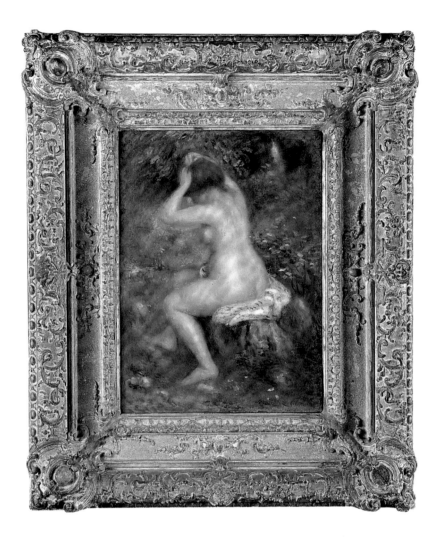

like it is not the one it had in the eighteenth century: the gilding has been muffled with a light grey toning or scraped off to reveal the white gesso. Such a finish suited the distinctive light palette and matt textures of Impressionist painting.

The idea of using second-hand frames spread from artists and their dealers to museums, and during the twentieth century curators have been striving to find old frames for old pictures or to make carefully aged imitations of old frames. It thus becomes hard for the visitor to know whether or not a frame is original.

Unlike much pedantic modern museum framing, some of the most successful marriages between old

frames and old paintings made earlier in this century were entirely anachronistic. The splendid oak frame around Correggio's 'School of Love', which perfectly complements with its rich leafy softness the sylvan setting and melting sensuality of that painting, was carved in France more than a century after the death of Correggio in Italy [22].

22. Correggio, *Venus with Mercury and Cupid ('The School of Love')*, 1520s, in a French frame of about 1650, 188 x 126 cm.

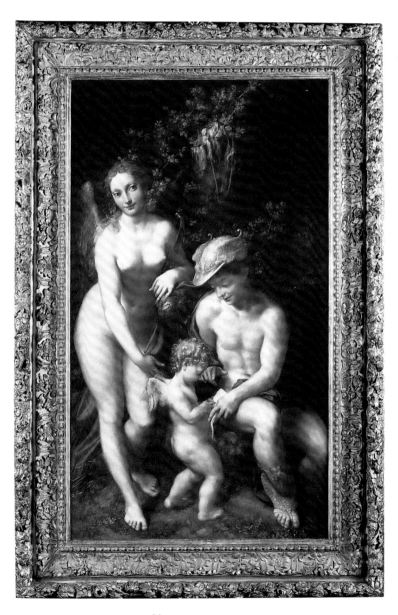

TABERNACLE
AND CASSETTA
FRAMES

Renaissance Italy

Tabernacle frames

Cassetta frames

Reverse-pattern frames

In the last chapter we surveyed some of the frames in the National Gallery that are original. We can now return to the Renaissance to examine two of the most popular types of early European picture frame, citing examples which are however now around paintings for which they were not made.

Most of the paintings made for domestic use in the late Middle Ages were devotional images. These were often given a miniature version of the architectural surrounds on altarpieces. Such frames were at first gothic in style like that around the *Crucifixion* [5] and then, increasingly in Italy during the fifteenth century, they adopted the architectural vocabulary of classical antiquity – with a projecting cornice, if not a full entablature, sometimes supported by columns or pilasters, and sometimes crowned by a gable in the form of a triangular or segmental pediment [23]. The frame thus formed a tabernacle, that is a dignified vertical architectural 'front', which also protected the image from the distractions of the world around it.

A good example made in Florence, probably in the workshop of Giuliano da Maiano (1432–90), has been placed round a Florentine Virgin and Child in the National Gallery, although originally it probably framed

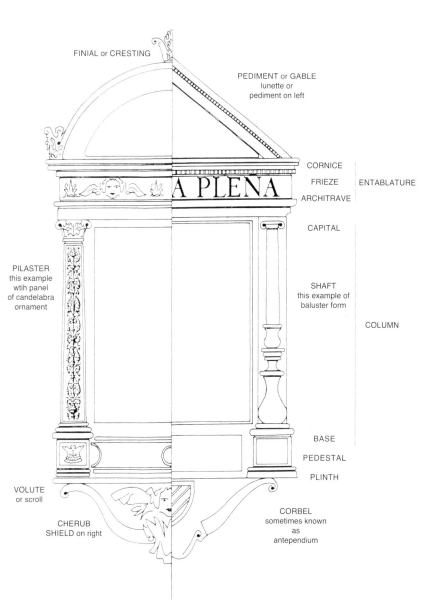

FINIAL or CRESTING

PEDIMENT or GABLE
lunette or
pediment on left

CORNICE

FRIEZE — ENTABLATURE

ARCHITRAVE

A PLENA

CAPITAL

PILASTER
this example
wtih panel
of candelabra
ornament

SHAFT
this example of
baluster form

COLUMN

BASE

PEDESTAL

PLINTH

VOLUTE
or scroll

CHERUB
SHIELD on right

CORBEL
sometimes known
as
antependium

a painted terracotta relief. The frame [24], which must date from about 1480, is very worn but some of its original gilding survives and so (very darkened) does the gold speckled blue paint on the supporting corbel, where the owner's arms were painted with a fluttering ribbon around the shield. The carving of this corbel, with its feathery foliage superimposed on its fluted scrolls, would have been very evident when the tabernacle was hung high on the wall (as we know they often were) with a candle on a separate bracket just below it. The

23. Diagram of a tabernacle frame showing some variations.

31

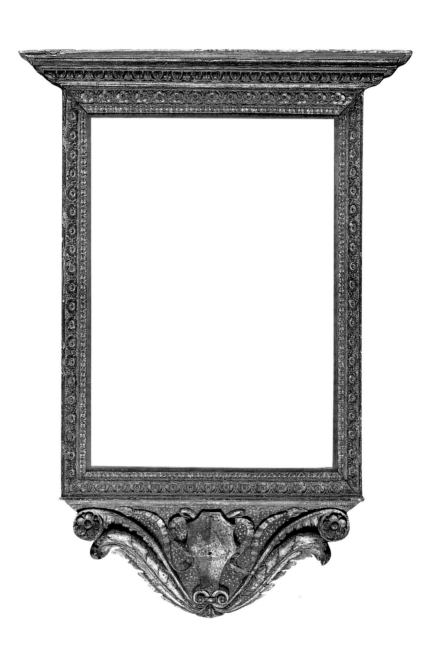

24. Florentine frame, perhaps Workshop of
Giuliano da Maiano, about 1470, probably
made for a terracotta relief (currently
displayed around *The Virgin and Child with
an Angel*, by an imitator of Fra Filippo Lippi,
about 1480), 114.3 x 62.1 cm.

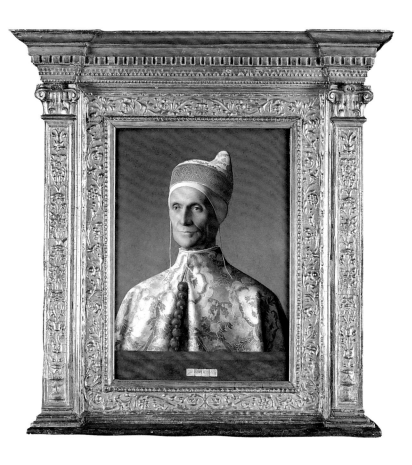

cornice, which is now broken, would have been sur-
mounted by a segmental pediment or lunette, proba-
bly with painted decoration.

A frame made probably about 1500 in Venice,
which earlier in this century was placed around
Giovanni Bellini's *Doge Leonardo Loredan*, includes
pilasters, also more of an entablature, although the
latter is a replacement [25]. The frame fits the portrait
perfectly, but it is most unlikely that any non-sacred
image was ever furnished with such a frame in the
Renaissance. Here the ornament – plant forms arising
from a vase in the pilasters, a leafy 'running pattern'
surrounding the picture – is not carved but executed
in *pastiglia* – a technique to which we will return (see
p. 54). The narrow, shelf-like plinth must have been
designed to rest upon a separate, elaborate corbel.

25. Venetian
frame, about
1500, probably for
a painting of the
Virgin and Child,
displayed around
Giovanni Bellini's
*Doge Leonardo
Loredan*, 1501–4,
93.5 x 86.5 cm.

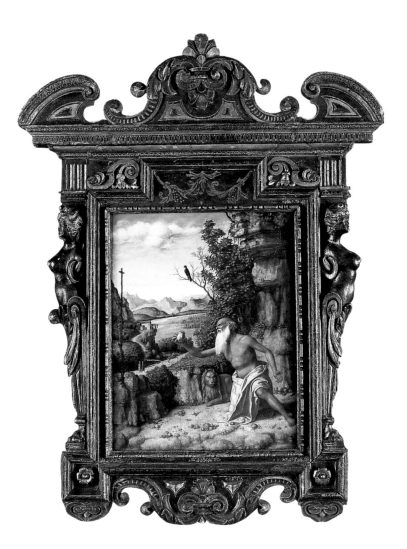

26. Italian frame, about 1560, probably made for a sacred image, displayed around Cima da Conegliano's *Saint Jerome in a Landscape*, about 1500–10. 64 x 49.8 cm.

Later in sixteenth-century Italy tabernacle frames assumed more curious and playful shapes – as in the extraordinary example that now surrounds a small painting of Saint Jerome [26]. The inner frame projects up into the entablature and down into the lower corners; its outer edge is defined by a bold moulding hollowed like a gutter. The pediment is divided and centres on cresting of acanthus. Female herms (architecture from the waist down) replace flanking columns. The frame is painted black to imitate ebony, with gilded decoration, some of it substituting for carved ornament (for example, the little 'flutes' or vertical hollows on the cornice).

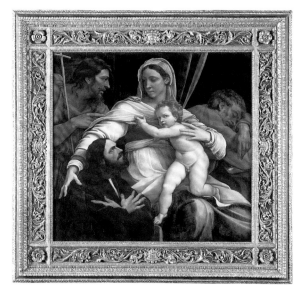

The most common form of frame made in Italy in the sixteenth century consists of a flat or slightly concave or convex frieze defined by distinct mouldings. This was known in Italy as a 'cassetta' frame – literally a small box frame. Some versions of these are descendants of the tabernacle frame – indeed, the innermost element of the frame round the Bellini [25] could be adapted as such. Frames of this kind often have ornament painted with gold or scratched to reveal gold in the frieze [3], but the finest have exquisitely carved ornament. No surviving example is finer than the Sienese frame of around 1510 placed on a slightly later painting by Sebastiano del Piombo [27]. The centre of the frieze is defined by a grotesque mask: its cheeks are pulled out into curling tendrils upon which winged monsters ride – a design only really effective when seen the right way up on the upper frieze [28].

THE CASSETTA FRAME

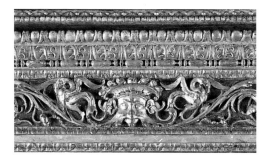

28. Detail of frame in 27.

By the middle of the sixteenth century wood – walnut, fruit wood, box wood or the much prized ebony – was more commonly exposed on frames, and details only were gilded, as was often also the case on bronzes. Although the basic design of a cassetta frame is simple, the mouldings could be very elaborate, especially at the outer edge, as in the late sixteenth-century Tuscan walnut frame around Bruegel's *Adoration of the Kings*. This frame is remarkable also for the gilding of small and intricate details [29, 30, 31, 33].

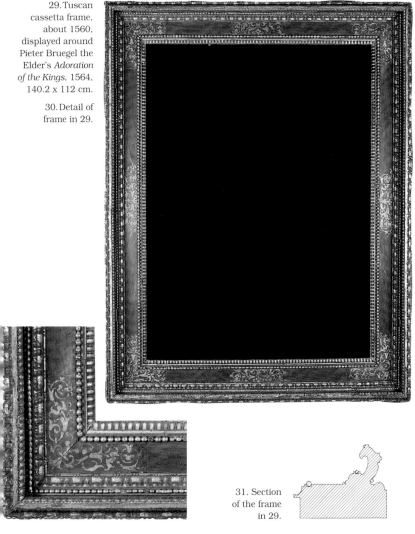

29. Tuscan cassetta frame, about 1560, displayed around Pieter Bruegel the Elder's *Adoration of the Kings*, 1564, 140.2 x 112 cm.

30. Detail of frame in 29.

31. Section of the frame in 29.

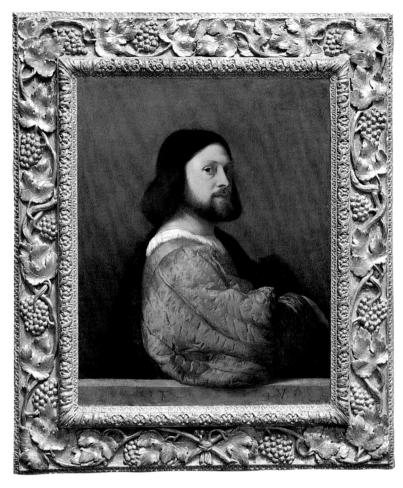

It was in the sixteenth century that picture galleries began to be a common feature of European palaces, and the cassetta was perhaps the most common type of frame used in them – in northern Europe as well as in Italy. But by the end of the sixteenth century another pattern of frame had become popular, the 'reverse' moulding in which the sight edge, the edge nearest the picture itself, is the most prominent feature of the frame and most of the frame steps or slopes away from it to the wall. Part of the appeal of such frames has been the way they united the frame with the wall. A rare early seventeenth-century reverse-pattern frame made in France now surrounds one of Titian's portraits, with a running pattern of serpents as well as vine leaves in the shallow hollow of the frieze [32].

32. French reverse pattern frame, about 1620, displayed around Titian's *Portrait of a Man*, about 1512, 114.2 x 98.8 cm.

THE REVERSE FRAME

Some frames of this type were originally silvered rather than gilded; the silver leaf was often toned to make a pale gold, which has seldom survived, for the glazes and varnishes darken or wear, and silver tarnishes. Combinations of gilding and silvering were much valued in the seventeenth century: if perfectly pre-served, this effect would certainly surprise us, and it would probably please us no better than the well-documented convention of hanging pictures on top of tapestries.

33. Corner of frame in 29. The frame has been slightly reduced at the corner, but the frieze was cut to either side of the corner decoration.

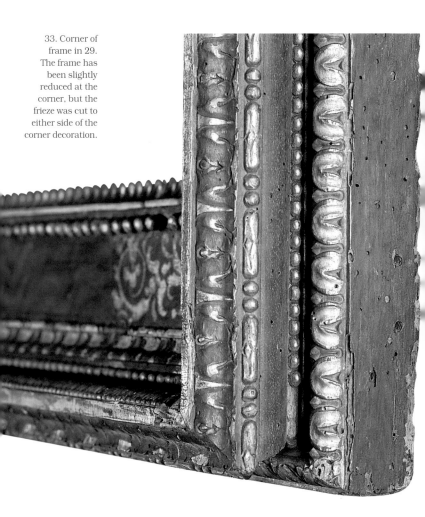

FRAMES
FOR
THE PICTURE
COLLECTOR

The seventeenth-century Netherlands
The auricular style and dark mouldings
Asymmetrical display

A s we saw in the last chapter, during the Renaissance the shape and style of a frame had much to do with the status of the picture it surrounded and with the circumstances of its display. Unfortunately, we know little about the display of paintings before 1600. After that date we find plenty of evidence in paintings themselves of how pictures were framed and hung. Yet it is hard to know what sort of historical value to attach to such evidence, particularly paintings of art collections – for even when documents demonstrate that the items depicted really did exist in the same collection, they seem implausibly crowded in the paintings. It is certainly hard to believe that pictures were ever assembled in such profusion and with so little regard for order as is suggested by the anonymous Flemish painting *Cognoscenti in in a Room hung with Pictures* [35]. It was, however, doubtless true that the more portable paintings in great collections were often taken down and examined closely, the

CROWDED
PICTURE
COLLECTION

39

34. Detail of painting in 35.

35. Flemish School, *Cognoscenti in a Room hung with Pictures*, probably Antwerp, about 1620, 95.9 x 123.5 cm.

gallery being more akin to a library than we might suppose. And the painting provides us with a reliable account of the types of frame preferred in that part of Europe in the first decades of the seventeenth century. Many are cassetta frames; hardly any of them are carved; none is entirely gilded.

Perhaps the most interesting frame in the whole painting is the one held by the man who looks out at us

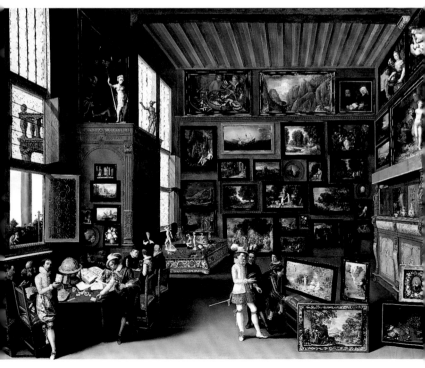

in the lower left corner [34]. He holds one of the curious little paintings that feature what seem to be random arrangements of life-size insects (pictures that were later to be a speciality of Jan van Kessel). The frame is fitted, as old looking glasses were, with a protective shutter: possibly the naturalistic impact of these pictures was increased not only by the artfully disordered arrangement of the insects depicted but also by the surprise they could provide when the shutter was drawn back.

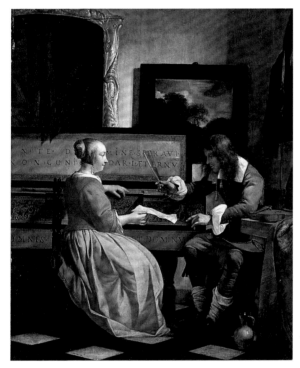

36. Gabriel Metsu, *A Man and a Woman seated by a Virginal*, Amsterdam, about 1665, 38.4 x 32.2 cm.

Fine paintings were found not only in grand galleries but in many smaller living rooms, as is clear from seventeenth-century inventories and from paintings of domestic episodes (usually scenes of courtship) by Dutch artists such as Vermeer and Metsu. The latter's *Man and Woman seated by a Virginal* of about 1665 actually includes one of Metsu's own earlier pictures in a gilded frame as well as a landscape in a black one [36]. The former is carved with ornament of a molten form with gristly convolutions like those of an ear. No example of this 'auricular' style exists on the walls

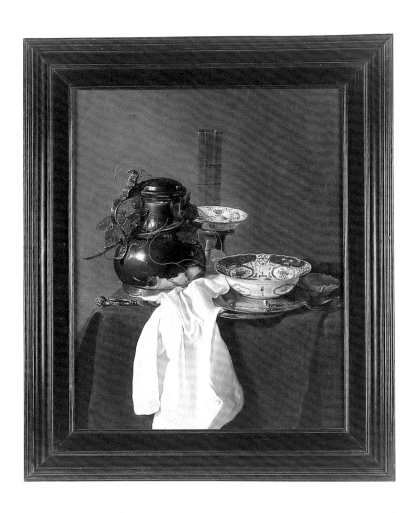

37. Dutch ebony frame, about 1650, displayed around Jan Jansz. Treck's *Still Life with a Pewter Flagon and Two Ming Bowls*, dated 1649, 98.5 x 86.2 cm.

of the National Gallery, but there are good examples of dark mouldings [37 and 38]. Their subtle design is as unobtrusive as the refinements of tailoring in gentleman's attire of the nineteenth and early twentieth centuries. Some of the sharp and rounded mouldings are minute and close together; the broader convexities and concavities, which are generally veneered, are often so shallow as to seem flat and the wave or ogee mouldings (mouldings that include both convex and concave curves) are easily misread [39]. Moreover, what seems black is in fact a varied dark brown natural to ebony and other exotic woods, and its polish is quite different to the glossy black imitations made in the nineteenth century.

A striking feature of interiors such as those painted by Metsu or Vermeer is the irregular display of the

38. Detail of 37. The frame has been reduced at the corners

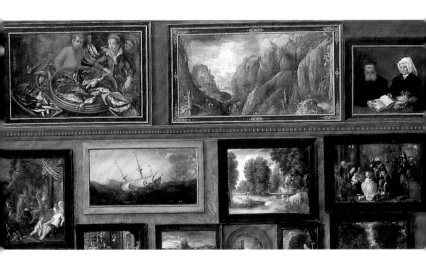

pictures on the often plain walls – it looks almost provisional, not only with varied frames but in asymmetrical arrangements. Except for large paintings hanging above central chimneypieces, paintings in the Netherlands in the seventeenth century were evidently often regarded as movables (to use the old English word for furniture) rather than as fixtures [40].

39. Section of the frame in 37 and 38.

40. Detail of paintings in 35.

FRAMES
FOR
THE PICTURE
GALLERY

The eighteenth and nineteenth centuries

Co-ordinated display in Italy

Carlo and Salvator frames

British architectural frames

Elaborate French frames

Richly carved frames for Old Masters

Italian palaces had often become very crowded with pictures by the early seventeenth century, but collectors seem always to have tried to impose some order in the way paintings were hung and often also some uniformity in the style of framing. For example, by the mid-seventeenth century the Medici favoured a distinctive type of very richly carved and gilded frame incorporating grotesque masks and pierced scrolls. It was given to paintings of all types and dates in the collection as a sort of uniform. Such a policy became the norm for many great collections thereafter.

A relatively simple frame was favoured for Roman picture galleries during the eighteenth century – one without centre or corner projections. Such frames could hang very close together, with a weight and width calculated to be effective around paintings of very different size and character. This versatile type of frame was often left on paintings when they had been sold out of Roman collections to British ones. The basic model was indeed so popular that London frame makers

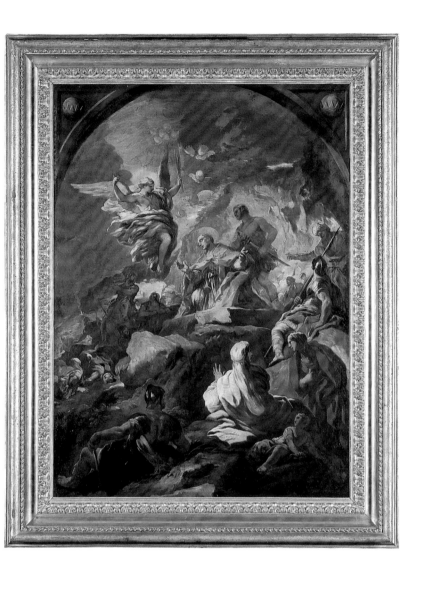

copied it for decades thereafter as a 'Carlo' or 'Salvator' pattern (the former had the acanthus leaf ornament in the principal hollow of the frame, the latter placed it at the sight edge). The names are derived from Carlo Maratta and Salvator Rosa, the Italian painters of the second half of the seventeenth century whose work presumably first appeared in London in such frames. An exceptionally fine frame of this type is found around the oil sketch by Luca Giordano [41].

41. Roman gallery frame, about 1770, displayed around Luca Giordano's *Martyrdom of Saint Januarius*, about 1690, 130.4 x 103.7 cm.

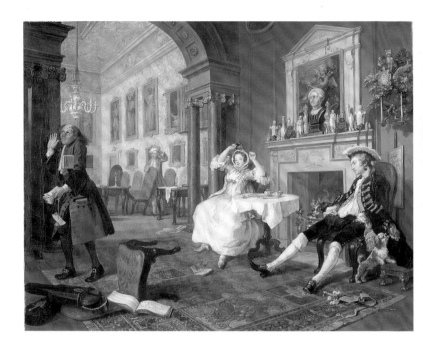

42. William
Hogarth, *Marriage
à la Mode: II,
Shortly after the
Marriage*, London,
early 1740s,
69.9 x 90.8 cm.

43 (opposite).
Detail of 42.

Hogarth's paintings in the *Marriage à la Mode* series give some idea of the palatial picture hang as it was imported into England in the eighteenth century. The Earl's fashionable medley of heathen gods and Catholic saints has uniform gilt frames (except for the cupid above the chimneypiece, framed in marble), and is ranged with architectural order in two tiers on rich silk fabric [42]. One picture, presumably a centre-piece, breaks the pattern and is curtained, like Metsu's own painting included in his picture [43]. Such covering served sometimes to protect pictures from flies or dust or sunlight, as was the case with a landscape by Rubens when the National Gallery first opened, but here it clearly ensures that an erotic subject was not normally visible to 'mixed company' or juveniles.

ARCHITEC-
TURAL FRAMES
IN BRITISH
HOUSES

Given the architectural character of many of the grander schemes of interior decoration, it is not surprising that frames were often designed by architects. Canaletto sold views of Venice chiefly to British clients not only as souvenirs but as wall decoration – hence often in pairs or quartets to flank the chimneypiece on a long wall, or to flank the doors on the two short walls of a room. One such pair in the National Gallery retains

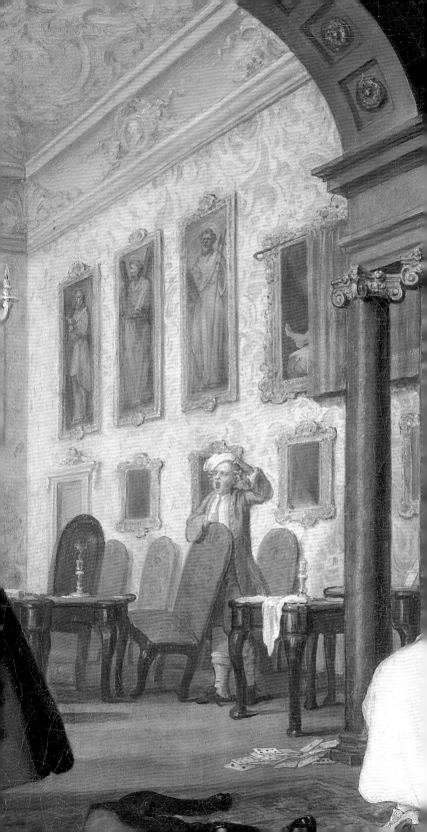

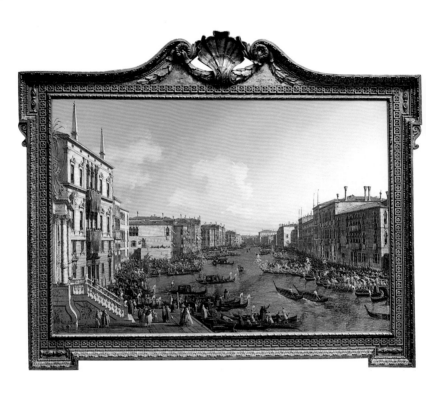

LUXURIOUS
FRENCH
FRAMES

English mid-eighteenth-century frames [44]. Doubtless the extended corners would have helped them to fit into a compartment of the wall. If the frames now seem too heavy for the pictures and if there is nothing in the pictures – no central element – to prompt the broken scrolling pediment with its shell, they may nevertheless have seemed right in the room, and all the ornament in the frames probably found some echo in the plaster-work there.

It was not only new paintings that were reframed for new rooms: Old Masters were also given new frames. One of the most remarkable frames in the National Gallery is the spectacular carved oak frame around Poussin's *Adoration of the Golden Calf* [45], which must date from about 1710 when the painting was in a Parisian collection (together with its pendant which is also still framed in the same style). We know from Poussin's letters that he gave his pictures plain mouldings with dull gilding. This frame has retained much of its glitter (inevitably exaggerated by electric lighting) and all of its deep relief. Its vitality upstages the dancing Israelites, especially now that the colours

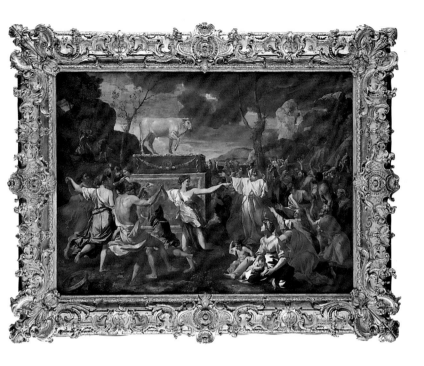

of the painting are duller and darker than they would once have been. But the frame would also have seemed less assertive in 1710 because it would have matched the room – the cornice above, the consoles beside it, the side table beneath it, all of carved wood, similarly gilt – whereas now it matches neither picture nor room.

The very rich setting such a frame provided was also a compliment to the painting: the finer the jewel

45. Nicolas Poussin, *The Adoration of the Golden Calf*, Rome, by 1634, with French frame, about 1700, 215 x 271 cm.

46. Detail of 45.

47. Adam
Elsheimer,
*The Baptism of
Christ*, Venice?,
probably
1598–1600,
with French frame,
about 1710,
53.5 x 47.5 cm.

the more lavish the setting; the flourishes of the carving also ensured that other pictures kept their distance as ordinary words must from a florid signature. The frame made for the precious little painting on copper of the *Baptism* by Elsheimer when it was in a French collection in the early eighteenth century is so broad in relation to the picture that it may be said to enshrine it [47]. The painting is here illustrated in its frame although that frame is normally kept in store in the Gallery and has been replaced by a modern frame imitating one of Elsheimer's own period.

The carving of pierced foliate ornament of exquisite fragility was especially characteristic of Italian frames,

VIRTUOSO
BAROQUE
CARVING

such as the one probably made in about 1700 by an Emilian carver for the highly damaged (but then newly restored) *Madonna and Child with Saint John* [48]. This particular example has survived largely intact thanks to the glass box placed round it in the gallery, but the original intention of open-work frames of this kind was often that they should hang against richly patterned fabrics with which they wittily half combined. The nineteenth century is associated with composition imitation of carving and with carving by machines; but in Italy especially virtuoso craftsmanship flourished and was exploited for exceptional frames commissioned for paintings of extraordinary value.

48. Attributed to Fra Bartolommeo, *The Madonna and Child with Saint John*, Florence, about 1516, in Emilian frame, about 1700, 108 x 96 cm.

49. Pisanello,
The Virgin and
Child with Saint
George and Saint
Anthony Abbot,
Ferrara, mid-
fifteenth century,
in an Italian frame
of about 1860
98.5 x 48.8 cm.

Collectors in the nineteenth century also commis-
sioned frames that revived the styles of the periods in
which their paintings were made. An especially
remarkable example is the gothic frame which Sir
Charles Eastlake had carved for his painting by
Pisanello [49]. It incorporates casts of a medallic por-
trait of Pisanello himself and of one made by him of the
Duke of Ferrara (a profile reminiscent of one in the
painting). This is an art historian's frame made as a
commentary on a specific painting without any refer-
ence to the circumstances of its display.

TEXTURE
AND DETAIL

Ornament and texture related to metalwork

Techniques of casting

Carving wood and gesso

Construction and its concealment

Gilding and regilding

Conservation of an old frame

So far in this book we have looked at frames in relation to the pictures they surround and to the rooms they were made to furnish. We can now look more closely at their ornament and finish. While the shapes and sections of picture frames are often closely related to architecture, their style of ornament may also be related to other arts. The auricular style exemplified by the gilt frame in Metsu's painting [36] was invented by goldsmiths. The leaves and reptiles in the French frame of the early seventeenth century [32] are found – often cast from actual specimens – in the ceramics made in the late sixteenth century by the great French potter, Bernard Palissy and in contemporary ornamental bronze work.

PASTIGLIA

The gilded wooden Florentine gothic altarpiece frame [5], which we looked at in the first chapter, resembles, in both general character and particular details the settings of gold, gilt silver and gilt copper made for reliquaries and the most precious shrines and images. The relief ornament of the frame actually incorporates glass beads equivalent to the precious stones with which such metalwork was embellished [50]. The relief on the frame is known in Italian as *pastiglia* and was formed by carefully dribbling gesso like icing a cake. With its soft edges it closely resembles ornament that has been embossed, that is punched and pressed into thin metal from behind – the *repoussé* technique common to much medieval work in precious metal.

50. Detail of pastiglia ornament in the predella of frame in 5, showing Saint Bernard.

Low relief ornament on frames was not always made by carving. The apparently continuous running pattern around the fifteenth-century Florentine tondo [13] is in fact cast in sections of four curls, while the rosettes are cast in pairs [51]. Tinfoil was driven into a

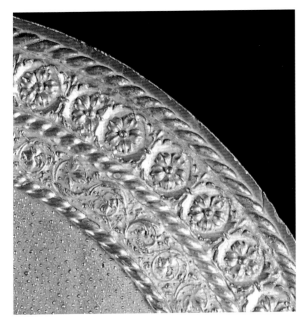

mould, then backed with wax and plaster. Foil, wax and plaster were then removed and applied to the wooden surface. Finally it was coated with gesso and gilded. Alternatives to tinfoil were stiff mixtures of paste which could be pressed into a mould – 'pasta di riso' (rice paste) and 'carta pesta' (*papier maché*). These were the ancestors of the 'compo' and plaster of Paris casts pioneered in the eighteenth century and mass produced in the nineteenth [18] but the earlier methods probably did not seek to be mistaken for carving, merely to provide an equivalent to it.

In the Renaissance sharply defined ornament on a frame was always carved in the wood, as in the early sixteenth-century Sienese frame [27 and 28] but when wood is prepared for gilding it tends to lose its sharpness because of the gesso coating – this can be exploited to give a softness to the modelling, but the gesso itself can also be cut. In fine French frames of the

52. Detail of
scratched
textures in the
carved frame in 45.

late seventeenth century or the early eighteenth we
may admire both the chiselling of the wood and the
tooling of the gesso – the work generally of different
craftsmen. The two processes correspond to those of
bronze working, where some of the character of the
finished work is due to the model that has been cast
and some to the treatment of the metal after casting. It
was the superb finishing of French gilt bronzes that
surely stimulated the pursuit of fine textures on gilded
picture frames in this period – indeed the very finest
picture frames made for the French royal palace of
Versailles were made of bronze. In a detail [52] of the

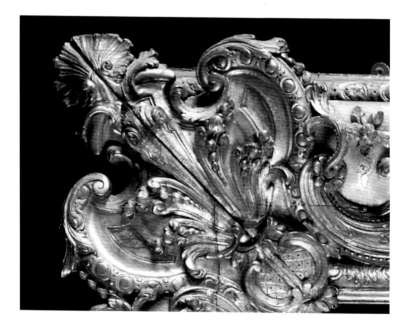

splendid frame made for Poussin's *Adoration of the
Golden Calf* [45] we may observe how the hatched and
crosshatched textures were scratched into the gesso
and the grooved surfaces of the curling leaves and
feathers cut into it rather than into the wood. On some
surfaces of this frame sand is mixed with the gesso –
an innovation perhaps stimulated by the fine 'matting'
of metal by hammering it with tiny points.

WATER
GILDING
AND
OIL GILDING

 The gilding of this frame, like most of the gilding
considered in this book, is known as water gilding. In
this method the gilder holds his breath, lifts a leaf of
gold on a brush and lets it settle upon the dampened

bole (the fine, usually ruddy, clay painted on the gesso). The slightly crinkled leaf is then pressed flat and burnished with a dog's tooth or hard stone. In no other method is burnishing possible. On this particular frame the burnishing was deliberately varied so that some elements were more reflective than others, especially in candlelight. It is unusual for the brilliance of old gilding to survive but it may be seen [53] in the hollow of the Roman frame around the Luca Giordano painting [41]. This is designed to contrast with the less burnished gilding of the exquisitely carved acanthus leaves and the shields between them and still more

53. Detail of burnished gilding in the hollow of the frame in 41.

with the outer moulding, which has been dulled by a glaze, now somewhat perished.

The alternative to water gilding is oil gilding, a process of applying gold leaf to a gesso (or occasionally wood) ground that has been coated with a tacky oil size or varnish, such as shellac. The ornament on the elaborate walnut frame of the sixteenth century is a good example [33]. It was the usual method of gilding in Britain in the eighteenth and nineteenth centuries, as for example on the frame of the Canaletto [44].

A frame often looks – and is intended to look – as if it consisted of four pieces of wood joined at the corners,

but the carved sections and higher mouldings (as well as veneers) were usually applied, often to a basic carcass in a different type of wood. The complex forms of many of the mouldings we have seen would not be possible but for the several layers of wood that were superimposed. This is obviously the case with the late sixteenth-century Tuscan walnut frame [30 and 33]. The 'shot' and 'bead' ornament in this case – as also the 'twisted ribbon' in the Roman eighteenth-century frame [53] –

54. Detail of attached orna-ment in the carved frame in 27.

are separately carved 'sticks' attached to the frame. This is also true of the 'bead and reel' ornament [54] in the edge of the outer mouldings of the Sienese frame now around the painting by Sebastiano del Piombo [27].

REGILDING

Picture frames have suffered from love as much as from neglect. One chief cause of damage has been the process of regilding, for this either entails applying a new coat of gesso over the whole surface, which eliminates

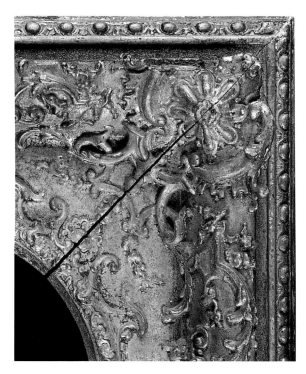

55. Detail of
clotted overgilding
of French frame
in 47.

all the carefully tooled textures and blunts all the sharp
detail, or it means applying oil gilding on top of the orig-
inal gilding, which has a similar effect [55]. More rarely,
it means stripping the frame down to the wood and
starting again. The other violence to which picture
frames have been repeatedly subjected is mutilation to
fit another picture: the craze for second-hand frames
has saved old frames from destruction – but only at a
price. Respect for their craftsmanship and design
(which this book hopes to encourage) should now
ensure that the finest are not only preserved but val-
ued as highly as their partners, the paintings.

It seems appropriate to conclude this book with a
fine example of a frame undergoing careful conserva-
tion and restoration in the Gallery's workshop [56]. It is
a 'Sansovino' frame, a type named after the architect
Jacopo Sansovino who worked in Venice in the mid-
sixteenth century, which was inspired by the contem-
porary designs made for stucco work and for the title-
pages of books. Much of the original water gilding has
survived, but the successive layers of gesso, shellac
and oil gilding that had covered the whole frame can be

RESTORATION

56. North Italian,
probably
Venetian, frame,
about 1590, of the
so-called
Sansovino pattern
here shown partly
restored.

57 (opposite).
Detail of
frame in 56.

seen as a series of stripes on its upper edge. The mask and cherubim were originally painted with flesh colour. This too has been recovered, and some blue background colour in which copper filings were embedded to produce an extra sparkle has been revealed. Losses have been replaced – the new scroll and a bird pecking at the swag of fruit were modelled on their surviving symmetrical equivalents – but more work remains to be done. There is no hurry because an appropriate partner for the frame has yet to be identified.

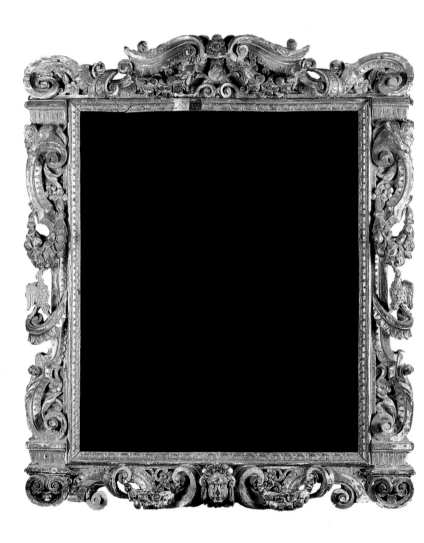

ACKNOWLEDGEMENTS

The author wishes to thank Paul Levi from whose survey of the Gallery's frames he has learnt so much, also John England, head of the Gallery's framing department, who has helped in numerous ways. Clare Keller made the measurements on which the sectional drawings are based.

All frames illustrated here are in the National Gallery, most of them on display. Some are on loan from the Victoria and Albert Museum, notably those illustrated on pages 32, 34 and 35. The measurements given for the frames in the captions are outside measurements.

FURTHER READING

R. Baldi and others, *La Cornice Fiorentina e Senese*, Florence, 1992.

M. Cämmerer-George, *Die Rahmung der Toskanischen altar-bilder im Trecento*, Strasbourg, 1966.

Designs for English Picture Frames, exhibition catalogue by P. Mason, Morton Morris & Co., London, 1987.

W. Ehlich, *Bilder-Rahmen von der Antike bis zur Romanik*, Dresden, 1979.

C. Grimm, *Alte Bilderrahmen: Epochen-Typen-Material*, Munich, 1978; published in English as *The Book of Picture Frames*, trans. N. Gordon and W. Strauss, with supplement by G. Szabo, New York, 1981.

M. Guggenheim, *Le Cornici Italiane*, Milan, 1897.

In Perfect Harmony : Picture and Frame 1850–1920, exhibition catalogue by E. Mendgen and others, Amsterdam, Van Gogh Museum, and Vienna, Kunstforum, 1995.

P. Mitchell, 'Italian Picture Frames, 1500–1825: A Brief Survey', *Furniture History*, vol. 20, 1984, pp. 18–47.

P. Mitchell and L. Roberts, *A History of European Picture Frames*, London, 1996 (first published in *The Dictionary of Art*, London, 1996).

P. Mitchell and L. Roberts, *Frameworks: Form, Function and Ornament in European Portrait Frames*, London, 1997.

G. Morazzoni, *Le Cornici Veneziane*, Milan 1944.

Of Gilding, exhibition catalogue by P. Mason and M. Gregory, Arnold Wiggins & Sons Ltd, London, 1989.

Polyptyques: le tableau multiple du moyen âge au vingtième siècle, exhibition catalogue by C. Clément, Paris, Musée du Louvre, 1990.

Prijst de Lijst:. De Hollandse schildrijlijst in de zeventiende eeuw, exhibition catalogue by P.J.J. van Thiel and C.J. de Bruyn Kops, Amsterdam, Rijksmuseum, 1984; published in English as *Framing in the Golden Age: Picture and frame in seventeenth-century Holland*, Zwolle, 1995.

Revue de l'art, no. 76, 1987, articles by A. Cecchi and others.

S. Roche, *Cadres français et étrangersz du XVe siècle au XVIIIe siècle*, Paris, 1931

F. Sabatelli, E. Colle and P. Zambrano, *La cornice Italiana dal Rinascimento al Neoclassico*, Milan, 1992.

The Art of the Picture Frame: Artists, Patrons and the Framing of Portraits in Britain, exhibition catalogue by J. Simon, London, National Portrait Gallery, 1996.

The Art of the Edge: European Frames, 1300–1900, exhibition catalogue by R. Brettell & A.S. Starling, Chicago, Art Institute of Chicago, 1986.

H. Verougstraete-Marcq and R. Van Schoute, *Cadres et supports dans la peinture flamande aux 15e et 16e siècles*, Heure-le-Romain, 1989.